ANGELA HARDING

DIARY 2023

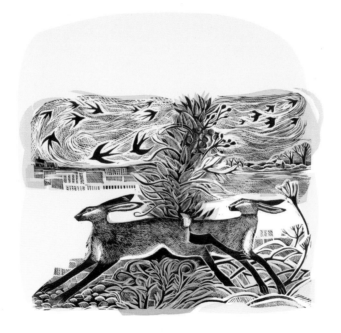

ANGELA HARDING is a fine art painter and illustrator based in Rutland, UK. She specialises in lino prints and her work is inspired by British birds and the countryside. In recent years she has worked as an illustrator for *Gardens Illustrated*, *BBC Countryfile* and *Country Living* magazine. She has a love for familiar garden birds, like the gaggle of sparrows that live in the ivy at the front of her house or the blackbirds that seem to feel they own her garden. Angela also loves the curlews, redshanks and other seabirds she sees when travelling further afield to Norfolk, Suffolk and Cornwall. She always takes a sketchbook on these trips.

First published in 2022

Created and Published by
FLAME TREE PUBLISHING
6 Melbray Mews,
London SW6 3NS, UK
Tel: +44 (0) 20 7751 9650
Fax: +44 (0) 20 7751 9651
info@flametreepublishing.com
www.flametreepublishing.com

ISBN: 978-1-80417-131-8

All images © Angela Harding 2022.
Front cover: *A Year Unfolding*
Back cover: *Visitors for Tea*
Double spreads, in order of appearance:
Terns at Sea, Southwold Swan, A Year Unfolding, October Owl, Scottish Robins.

A CIP record for this book is available from the British Library upon request.

Every attempt has been made to ensure the accuracy of the date information at the time of going
to press, and the publishers cannot accept responsibility for any errors. Some public holidays are subject
to change by Royal or State proclamation. At the time of publication, accurate information was unavailable
for all religious celebrations in 2023. All Jewish and Islamic holidays begin at sunset on the previous
day and end at sunset on the date shown. Moon phases are based on GMT.

Every effort has been made to contact all copyright holders. The publishers
would be pleased to hear if any oversights or omissions have occurred.

Created and Published in UK. Printed in China.

New Moon

First Quarter

Full Moon

Last Quarter

2022

JANUARY
S	M	T	W	T	F	S
						1
2	3	4	5	6	7	8
9	10	11	12	13	14	15
16	17	18	19	20	21	22
23	24	25	26	27	28	29
30	31					

FEBRUARY
S	M	T	W	T	F	S
		1	2	3	4	5
6	7	8	9	10	11	12
13	14	15	16	17	18	19
20	21	22	23	24	25	26
27	28					

MARCH
S	M	T	W	T	F	S
		1	2	3	4	5
6	7	8	9	10	11	12
13	14	15	16	17	18	19
20	21	22	23	24	25	26
27	28	29	30	31		

APRIL
S	M	T	W	T	F	S
					1	2
3	4	5	6	7	8	9
10	11	12	13	14	15	16
17	18	19	20	21	22	23
24	25	26	27	28	29	30

MAY
S	M	T	W	T	F	S
1	2	3	4	5	6	7
8	9	10	11	12	13	14
15	16	17	18	19	20	21
22	23	24	25	26	27	28
29	30	31				

JUNE
S	M	T	W	T	F	S
			1	2	3	4
5	6	7	8	9	10	11
12	13	14	15	16	17	18
19	20	21	22	23	24	25
26	27	28	29	30		

JULY
S	M	T	W	T	F	S
					1	2
3	4	5	6	7	8	9
10	11	12	13	14	15	16
17	18	19	20	21	22	23
24	25	26	27	28	29	30
31						

AUGUST
S	M	T	W	T	F	S
	1	2	3	4	5	6
7	8	9	10	11	12	13
14	15	16	17	18	19	20
21	22	23	24	25	26	27
28	29	30	31			

SEPTEMBER
S	M	T	W	T	F	S
				1	2	3
4	5	6	7	8	9	10
11	12	13	14	15	16	17
18	19	20	21	22	23	24
25	26	27	28	29	30	

OCTOBER
S	M	T	W	T	F	S
						1
2	3	4	5	6	7	8
9	10	11	12	13	14	15
16	17	18	19	20	21	22
23	24	25	26	27	28	29
30	31					

NOVEMBER
S	M	T	W	T	F	S
		1	2	3	4	5
6	7	8	9	10	11	12
13	14	15	16	17	18	19
20	21	22	23	24	25	26
27	28	29	30			

DECEMBER
S	M	T	W	T	F	S
				1	2	3
4	5	6	7	8	9	10
11	12	13	14	15	16	17
18	19	20	21	22	23	24
25	26	27	28	29	30	31

2023

JANUARY
S	M	T	W	T	F	S
1	2	3	4	5	6	7
8	9	10	11	12	13	14
15	16	17	18	19	20	21
22	23	24	25	26	27	28
29	30	31				

FEBRUARY
S	M	T	W	T	F	S
			1	2	3	4
5	6	7	8	9	10	11
12	13	14	15	16	17	18
19	20	21	22	23	24	25
26	27	28				

MARCH
S	M	T	W	T	F	S
			1	2	3	4
5	6	7	8	9	10	11
12	13	14	15	16	17	18
19	20	21	22	23	24	25
26	27	28	29	30	31	

APRIL
S	M	T	W	T	F	S
						1
2	3	4	5	6	7	8
9	10	11	12	13	14	15
16	17	18	19	20	21	22
23	24	25	26	27	28	29
30						

MAY
S	M	T	W	T	F	S
	1	2	3	4	5	6
7	8	9	10	11	12	13
14	15	16	17	18	19	20
21	22	23	24	25	26	27
28	29	30	31			

JUNE
S	M	T	W	T	F	S
				1	2	3
4	5	6	7	8	9	10
11	12	13	14	15	16	17
18	19	20	21	22	23	24
25	26	27	28	29	30	

JULY
S	M	T	W	T	F	S
						1
2	3	4	5	6	7	8
9	10	11	12	13	14	15
16	17	18	19	20	21	22
23	24	25	26	27	28	29
30	31					

AUGUST
S	M	T	W	T	F	S
		1	2	3	4	5
6	7	8	9	10	11	12
13	14	15	16	17	18	19
20	21	22	23	24	25	26
27	28	29	30	31		

SEPTEMBER
S	M	T	W	T	F	S
					1	2
3	4	5	6	7	8	9
10	11	12	13	14	15	16
17	18	19	20	21	22	23
24	25	26	27	28	29	30

OCTOBER
S	M	T	W	T	F	S
1	2	3	4	5	6	7
8	9	10	11	12	13	14
15	16	17	18	19	20	21
22	23	24	25	26	27	28
29	30	31				

NOVEMBER
S	M	T	W	T	F	S
			1	2	3	4
5	6	7	8	9	10	11
12	13	14	15	16	17	18
19	20	21	22	23	24	25
26	27	28	29	30		

DECEMBER
S	M	T	W	T	F	S
					1	2
3	4	5	6	7	8	9
10	11	12	13	14	15	16
17	18	19	20	21	22	23
24	25	26	27	28	29	30
31						

2024

JANUARY
S	M	T	W	T	F	S
	1	2	3	4	5	6
7	8	9	10	11	12	13
14	15	16	17	18	19	20
21	22	23	24	25	26	27
28	29	30	31			

FEBRUARY
S	M	T	W	T	F	S
				1	2	3
4	5	6	7	8	9	10
11	12	13	14	15	16	17
18	19	20	21	22	23	24
25	26	27	28	29		

MARCH
S	M	T	W	T	F	S
					1	2
3	4	5	6	7	8	9
10	11	12	13	14	15	16
17	18	19	20	21	22	23
24	25	26	27	28	29	30
31						

APRIL
S	M	T	W	T	F	S
	1	2	3	4	5	6
7	8	9	10	11	12	13
14	15	16	17	18	19	20
21	22	23	24	25	26	27
28	29	30				

MAY
S	M	T	W	T	F	S
			1	2	3	4
5	6	7	8	9	10	11
12	13	14	15	16	17	18
19	20	21	22	23	24	25
26	27	28	29	30	31	

JUNE
S	M	T	W	T	F	S
						1
2	3	4	5	6	7	8
9	10	11	12	13	14	15
16	17	18	19	20	21	22
23	24	25	26	27	28	29
30						

JULY
S	M	T	W	T	F	S
	1	2	3	4	5	6
7	8	9	10	11	12	13
14	15	16	17	18	19	20
21	22	23	24	25	26	27
28	29	30	31			

AUGUST
S	M	T	W	T	F	S
				1	2	3
4	5	6	7	8	9	10
11	12	13	14	15	16	17
18	19	20	21	22	23	24
25	26	27	28	29	30	31

SEPTEMBER
S	M	T	W	T	F	S
1	2	3	4	5	6	7
8	9	10	11	12	13	14
15	16	17	18	19	20	21
22	23	24	25	26	27	28
29	30					

OCTOBER
S	M	T	W	T	F	S
		1	2	3	4	5
6	7	8	9	10	11	12
13	14	15	16	17	18	19
20	21	22	23	24	25	26
27	28	29	30	31		

NOVEMBER
S	M	T	W	T	F	S
					1	2
3	4	5	6	7	8	9
10	11	12	13	14	15	16
17	18	19	20	21	22	23
24	25	26	27	28	29	30

DECEMBER
S	M	T	W	T	F	S
1	2	3	4	5	6	7
8	9	10	11	12	13	14
15	16	17	18	19	20	21
22	23	24	25	26	27	28
29	30	31				

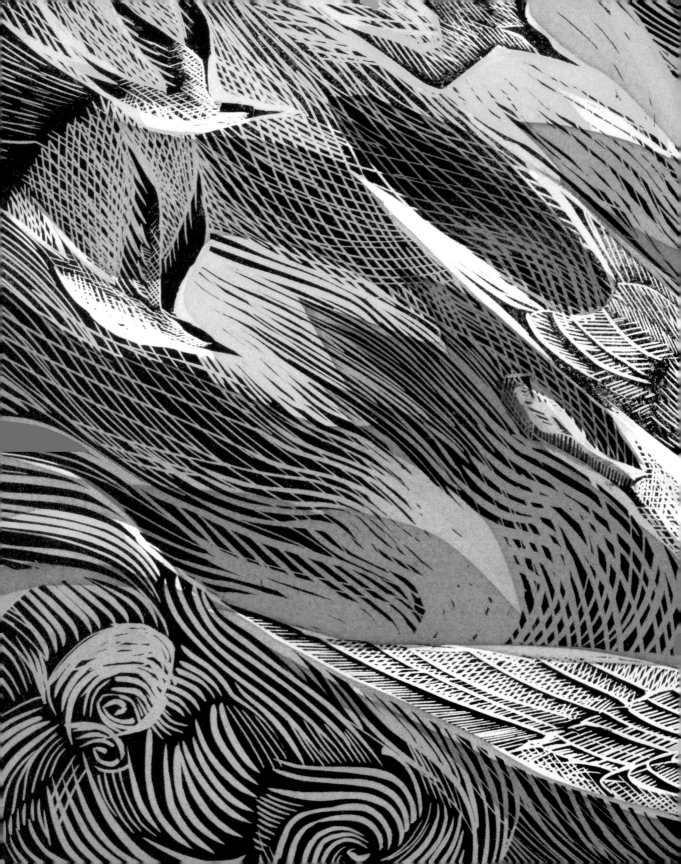

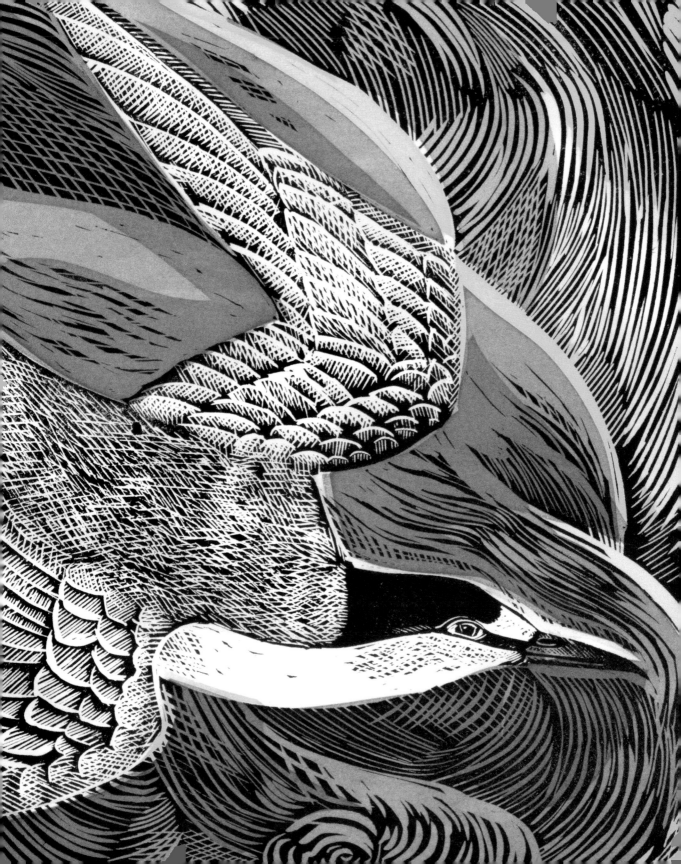

Personal Information

Name

Address

Telephone

Mobile

Fax

Email

Bank Telephone

Credit Card Telephone

National Insurance No.

Passport No.

Driving Licence No.

AA or RAC Membership No.

In Case of Emergency

Contact

Telephone

Doctor

Known Allergies

Notes

December 2022/January 2023

26 Monday

Boxing Day
Hanukkah ends
Day of Goodwill (SA)
St Stephen's Day (Éire)

27 Tuesday

Christmas Day (observed)

28 Wednesday

29 Thursday

Birthday of Guru Gobind Singh

30 Friday

31 Saturday

New Year's Eve

1 Sunday

New Year's Day

January

2 Monday

Public Holiday (Scot, NZ)
New Year's Day (observed)

3 Tuesday

Public Holiday (Scot, NZ) (observed)

4 Wednesday

5 Thursday

6 Friday

Epiphany
Three Kings' Day

7 Saturday

8 Sunday

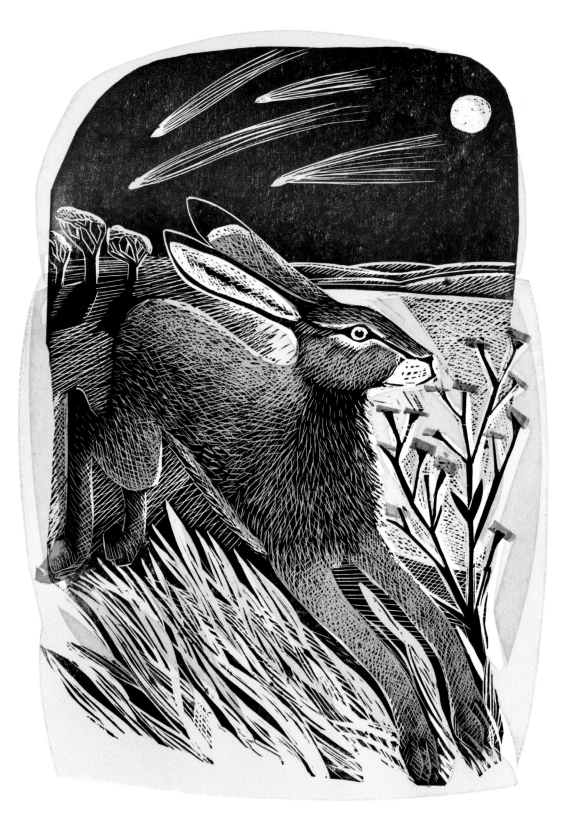

January

9 Monday

Coming of Age Day (Japan)

10 Tuesday

11 Wednesday

12 Thursday

13 Friday

14 Saturday

Makar Sankranti

15 Sunday

Shooting Stars
© Angela Harding 2022

January

16 Monday

17 Tuesday

18 Wednesday

19 Thursday

20 Friday

21 Saturday ●

22 Sunday

Chinese New Year
Year of the Rabbit

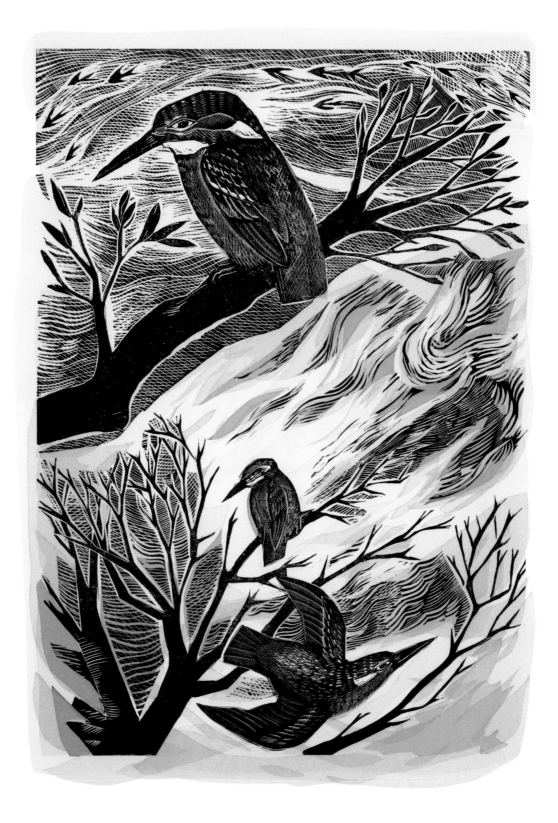

January

23 Monday

24 Tuesday

25 Wednesday

Vasant Panchami
Burns Night (Scot)

26 Thursday

Australia Day

27 Friday

28 Saturday

29 Sunday

January/February

30 Monday

31 Tuesday

1 Wednesday

2 Thursday

Groundhog Day (USA, Canada)

3 Friday

4 Saturday

○ 5 Sunday

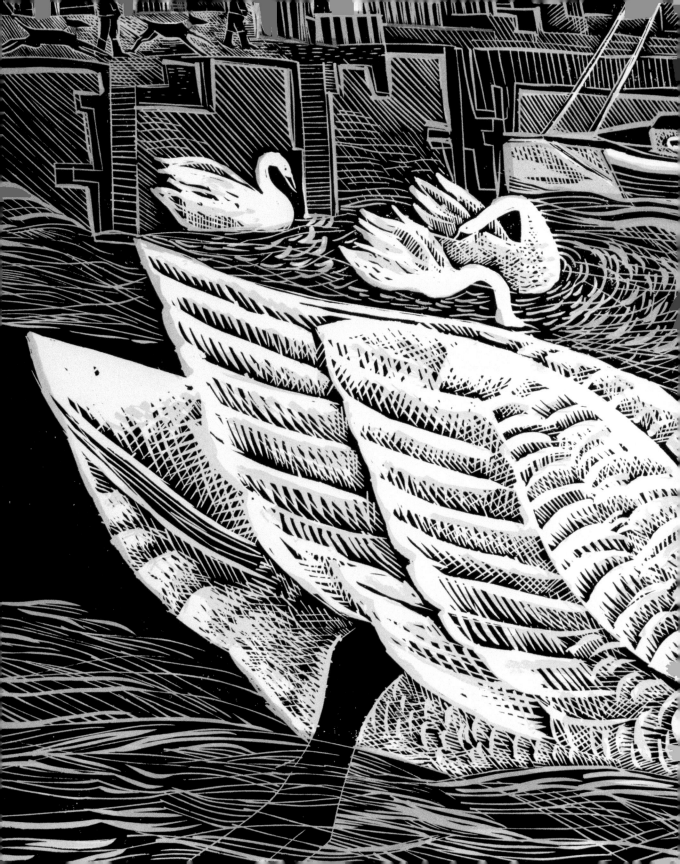

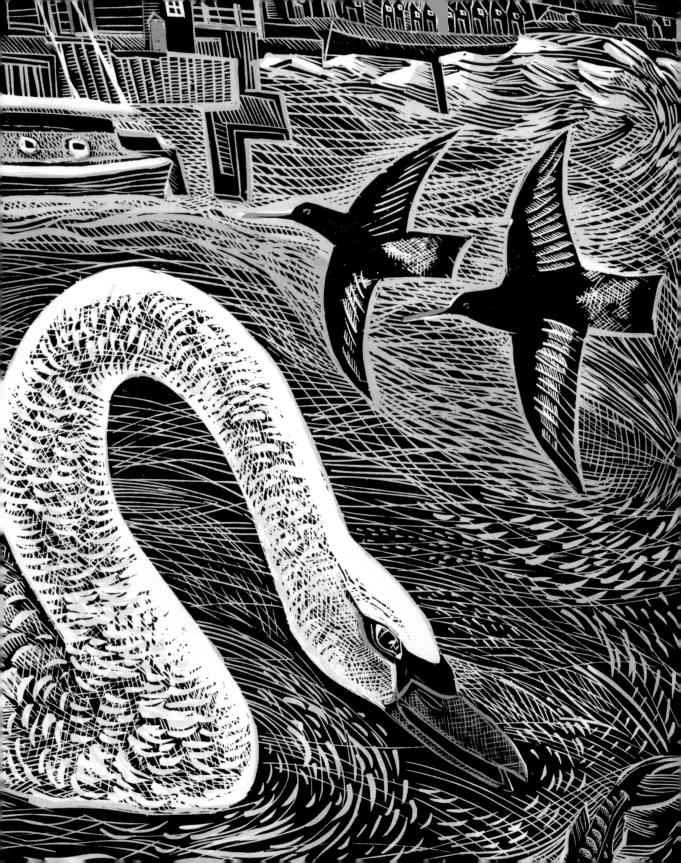

February

6 Monday

Waitangi Day (NZ)

7 Tuesday

8 Wednesday

9 Thursday

10 Friday

11 Saturday

National Foundation Day (Japan)

12 Sunday

The Gardener's Cottage
© Angela Harding 2022

February

13 Monday ◑

14 Tuesday

St Valentine's Day

15 Wednesday

16 Thursday

17 Friday

18 Saturday

Maha Shivaratri

19 Sunday

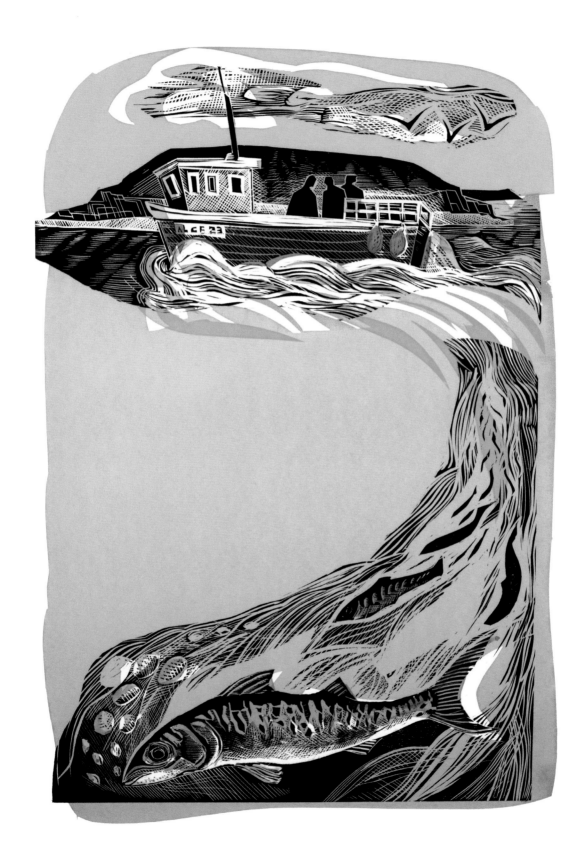

February

20 Monday

●

21 Tuesday

Shrove Tuesday
Pancake Day

22 Wednesday

Ash Wednesday

23 Thursday

The Emperor's Birthday (Japan)

24 Friday

25 Saturday

26 Sunday

First Sunday of Lent

February/March

27 Monday

28 Tuesday

1 Wednesday

St David's Day (Wales)

2 Thursday

3 Friday

4 Saturday

5 Sunday

March

6 Monday

7 Tuesday

Purim
Holi

8 Wednesday

International Women's Day
Hola Mohalla begins

9 Thursday

10 Friday

Hola Mohalla ends

11 Saturday

12 Sunday

Hares at Orford Ness
© Angela Harding 2022

March

13 Monday

14 Tuesday

15 Wednesday

16 Thursday

17 Friday

St Patrick's Day

18 Saturday

19 Sunday

Mother's Day (UK, Éire)

Shippen Curlew
© Angela Harding 2022

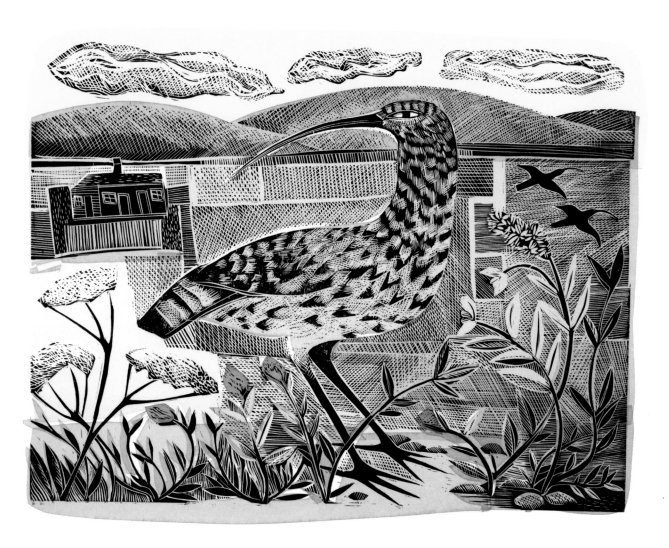

March

20 Monday

21 Tuesday

22 Wednesday

23 Thursday

24 Friday

25 Saturday

26 Sunday

March/April

27 Monday

28 Tuesday

29 Wednesday

30 Thursday

Rama Navami

31 Friday

1 Saturday

2 Sunday

Palm Sunday

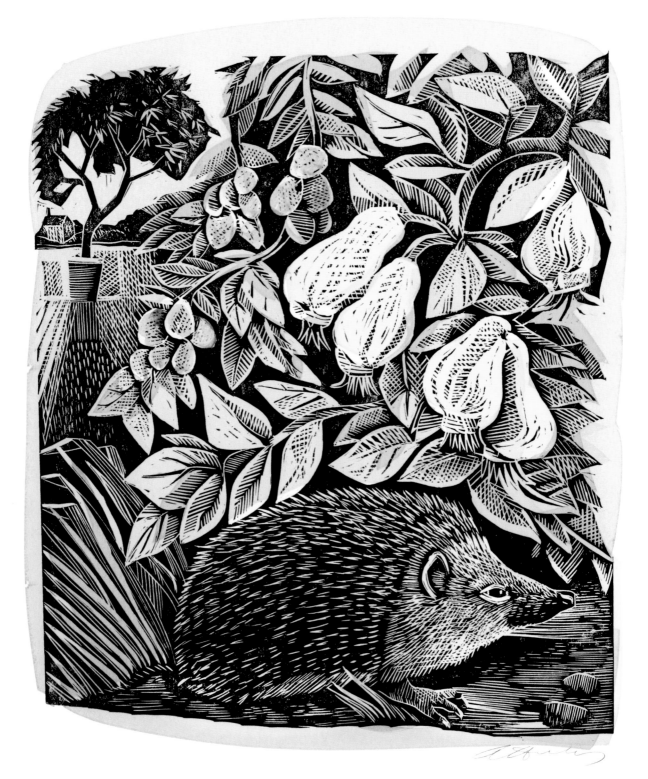

April

3 Monday

4 Tuesday

5 Wednesday

○ 6 Thursday

Maundy Thursday
Hanuman Jayanti
First Day of Passover (Pesach)

7 Friday

Good Friday

8 Saturday

9 Sunday

Easter Sunday

Hidden Hedgehog
© Angela Harding 2022

April

10 Monday

Easter Monday
Family Day (SA)

11 Tuesday

12 Wednesday

13 Thursday

Last Day of Passover (Pesach)

14 Friday

Vaisakhi

15 Saturday

16 Sunday

Grey Wagtails
© Angela Harding 2022

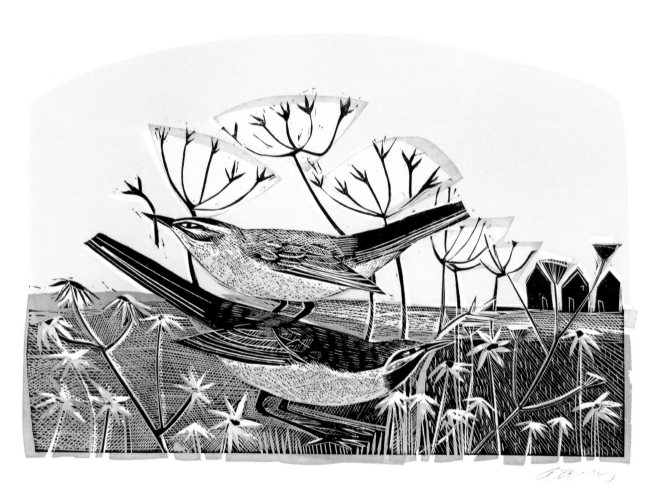

April

17 Monday

18 Tuesday

19 Wednesday

20 Thursday ●

Ramadan ends

21 Friday

22 Saturday

Eid al-Fitr

23 Sunday

St George's Day (England)

April

24 Monday

25 Tuesday

Anzac Day (AU, NZ)

26 Wednesday

27 Thursday

Day (SA)

28 Friday

29 Saturday

Shōwa Day (Japan)

30 Sunday

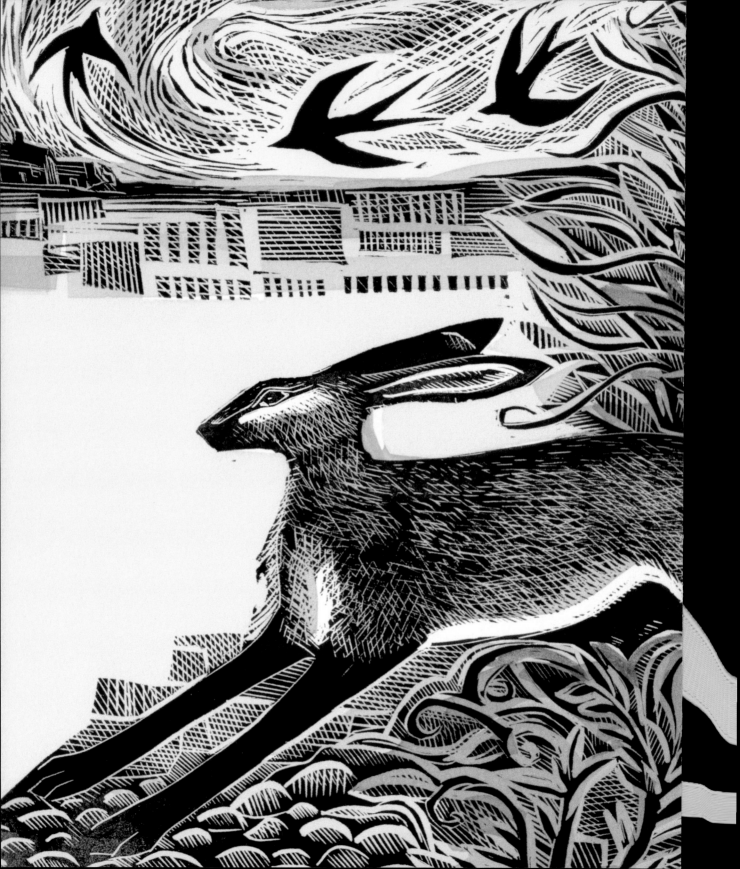

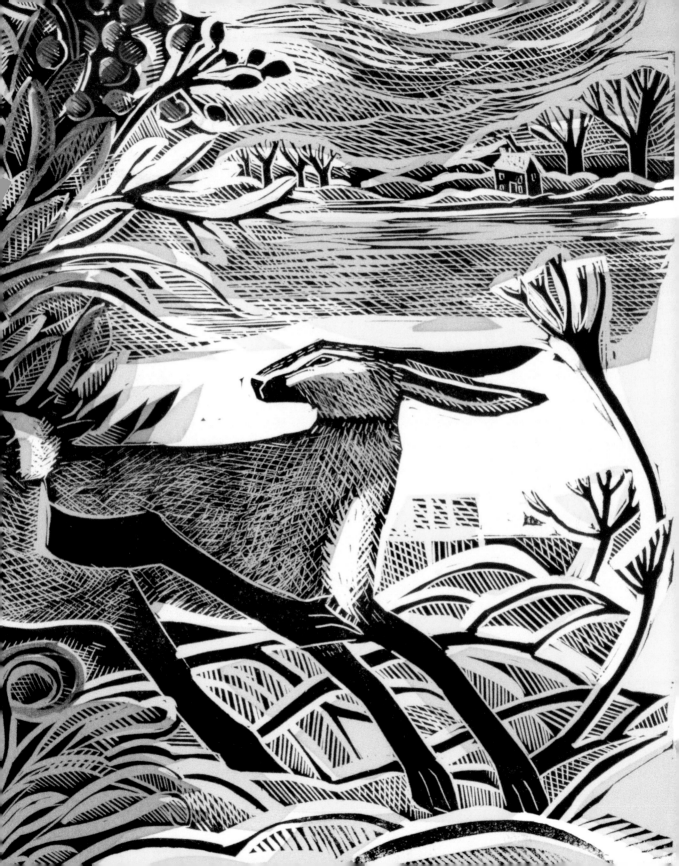

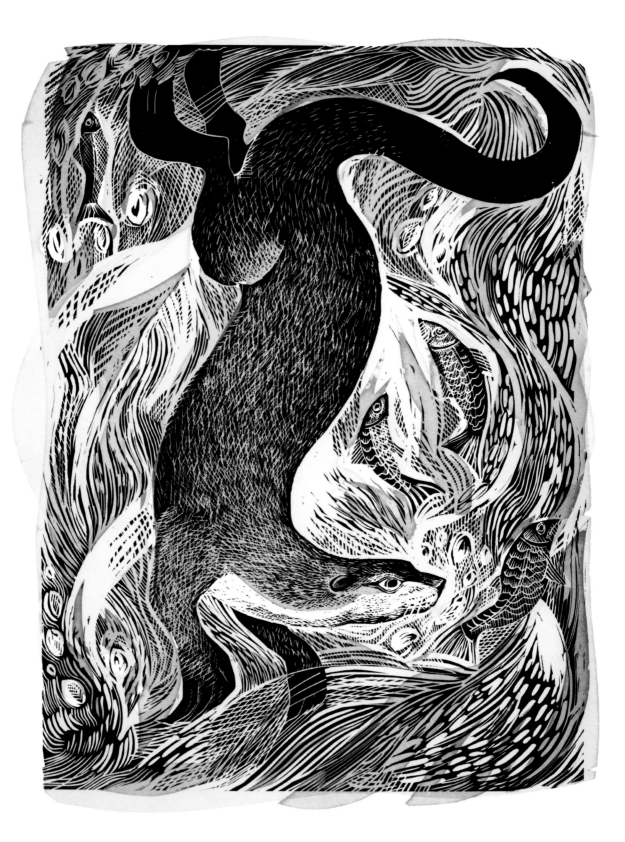

May

1 Monday

Workers' Day (SA)
May Bank Holiday (UK, Éire)

2 Tuesday

3 Wednesday

Constitution Memorial Day (Japan)

4 Thursday

Greenery Day (Japan)

○

5 Friday

Vesak Day
Children's Day (Japan)

6 Saturday

7 Sunday

Fishing Otter
© Angela Harding 2022

May

8 Monday

9 Tuesday

10 Wednesday

11 Thursday

12 Friday ◑

13 Saturday

14 Sunday

Mother's Day (USA, Canada, AU, NZ, SA, Japan)

Black Throated Diver
© Angela Harding 2022

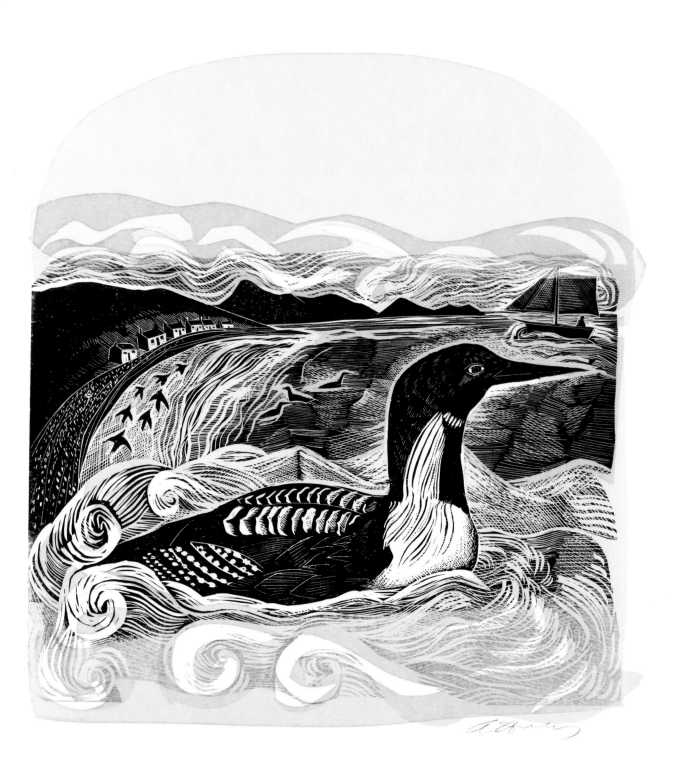

May

15 Monday

16 Tuesday

17 Wednesday

18 Thursday

Ascension Day

19 Friday ●

20 Saturday

21 Sunday

May

22 Monday

Victoria Day (Canada)

23 Tuesday

24 Wednesday

25 Thursday

26 Friday

Shavuot begins

◐ 27 Saturday

Shavuot ends

28 Sunday

Pentecost

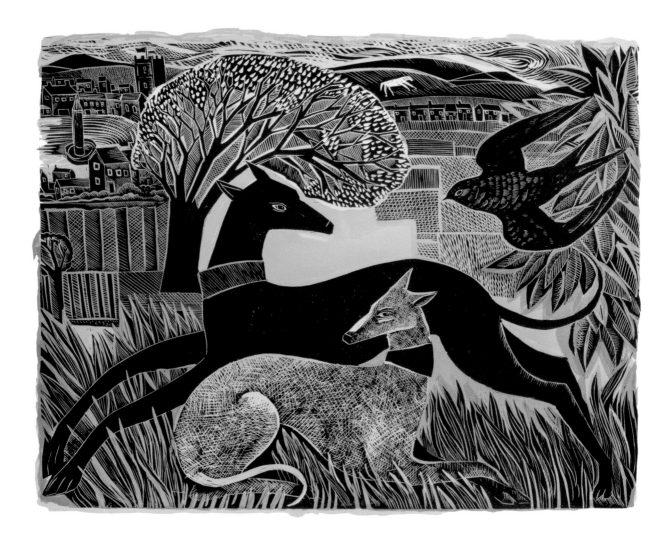

May/June

29 Monday

Whit Monday
Memorial Day (USA)
Spring Bank Holiday (UK)

30 Tuesday

31 Wednesday

1 Thursday

2 Friday

Coronation Day (UK)

3 Saturday

○

4 Sunday

Trinity Sunday

Two Yorkshire Whippets
© Angela Harding 2022

June

5 Monday

<div align="right">June Bank Holiday (Éire)</div>

6 Tuesday

7 Wednesday

8 Thursday

<div align="right">Corpus Christi</div>

9 Friday

10 Saturday ◐

<div align="right">The Queen's Official Birthday (UK)</div>

11 Sunday

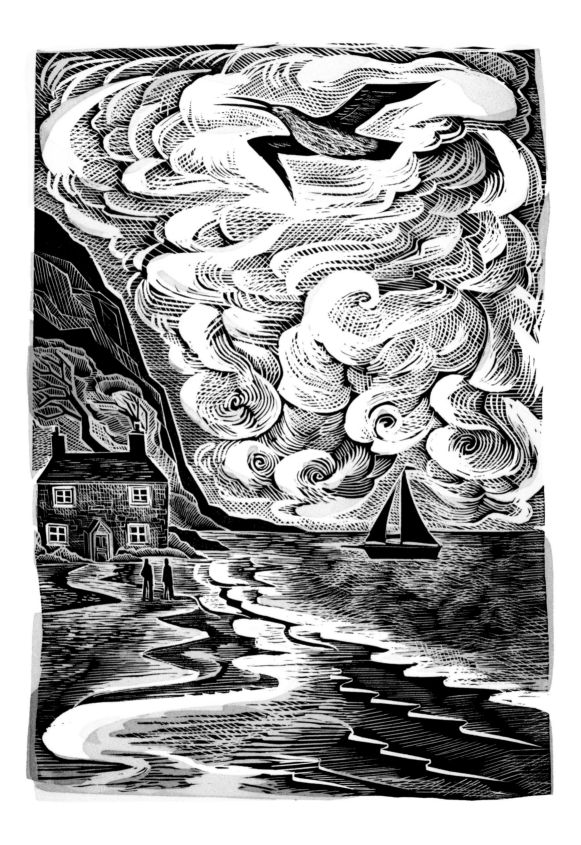

June

12 Monday

13 Tuesday

14 Wednesday

15 Thursday

16 Friday

Youth Day (SA)
Martyrdom of Guru Arjan Dev

17 Saturday

18 Sunday

Father's Day (UK, Éire, USA, Canada, SA, Japan)

June

19 Monday

Juneteenth

20 Tuesday

21 Wednesday

Summer Solstice

22 Thursday

Windrush Day (UK)
Dragon Boat Festival

23 Friday

24 Saturday

25 Sunday

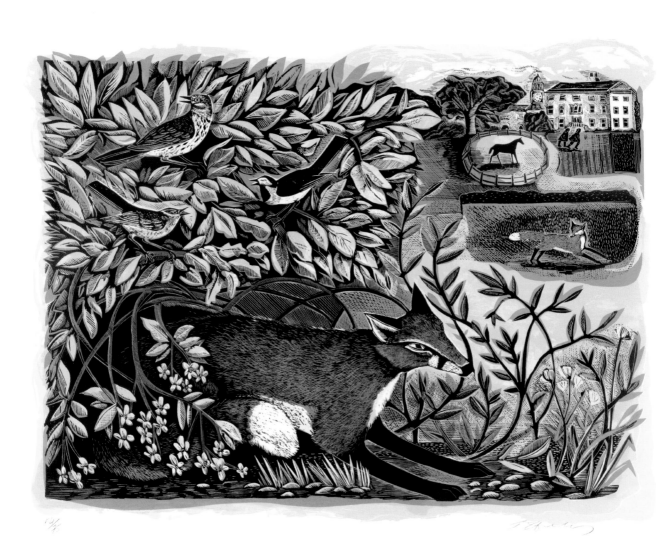

June/July

26 Monday

27 Tuesday

28 Wednesday

29 Thursday

Eid al-Adha

30 Friday

1 Saturday

Canada Day

2 Sunday

Summer Foxes at Marske Hall
© Angela Harding 2022

July

3 Monday ○

Canada Day (observed)

4 Tuesday

Independence Day (USA)

5 Wednesday

6 Thursday

7 Friday

8 Saturday

9 Sunday

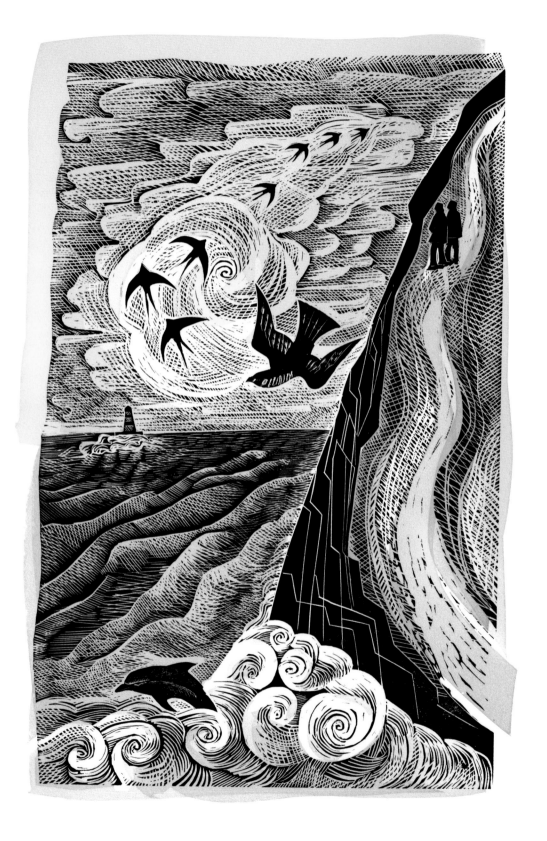

July

10 Monday

11 Tuesday

12 Wednesday

Battle of the Boyne (N. Ireland)

13 Thursday

14 Friday

15 Saturday

16 Sunday

July

17 Monday

Marine Day (Japan)

18 Tuesday

19 Wednesday

Islamic New Year
Muharram

20 Thursday

21 Friday

22 Saturday

23 Sunday

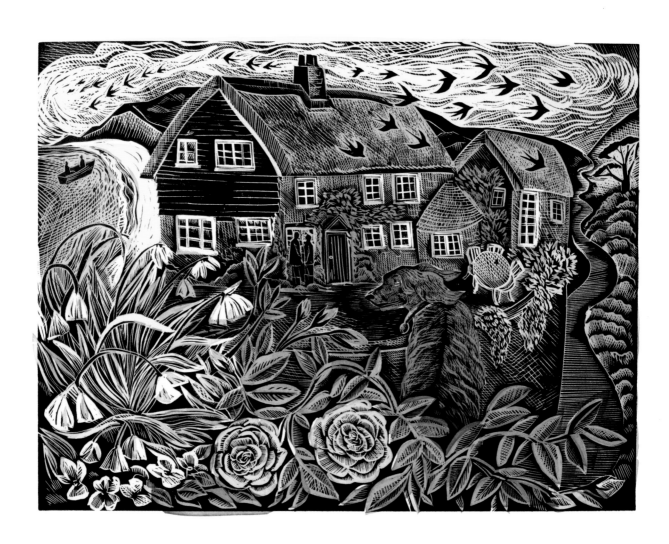

July

24 Monday

25 Tuesday

26 Wednesday

27 Thursday

Tisha B'Av

28 Friday

29 Saturday

30 Sunday

July/August

31 Monday

1 Tuesday ◯

2 Wednesday

3 Thursday

4 Friday

5 Saturday

6 Sunday

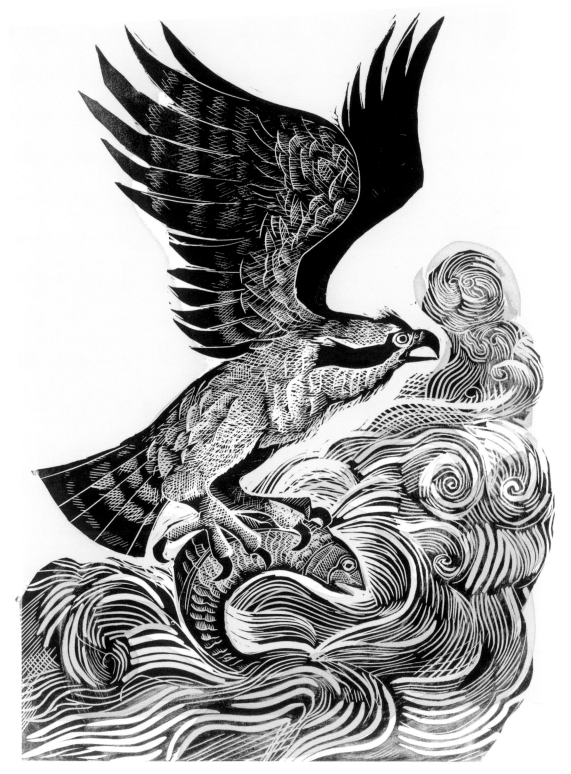

August

7 Monday

August Bank Holiday (Éire)
Summer Bank Holiday (Scot)

8 Tuesday

9 Wednesday

National Women's Day (SA)

10 Thursday

11 Friday

Mountain Day (Japan)

12 Saturday

13 Sunday

August

14 Monday

15 Tuesday

16 Wednesday

17 Thursday

18 Friday

19 Saturday

20 Sunday

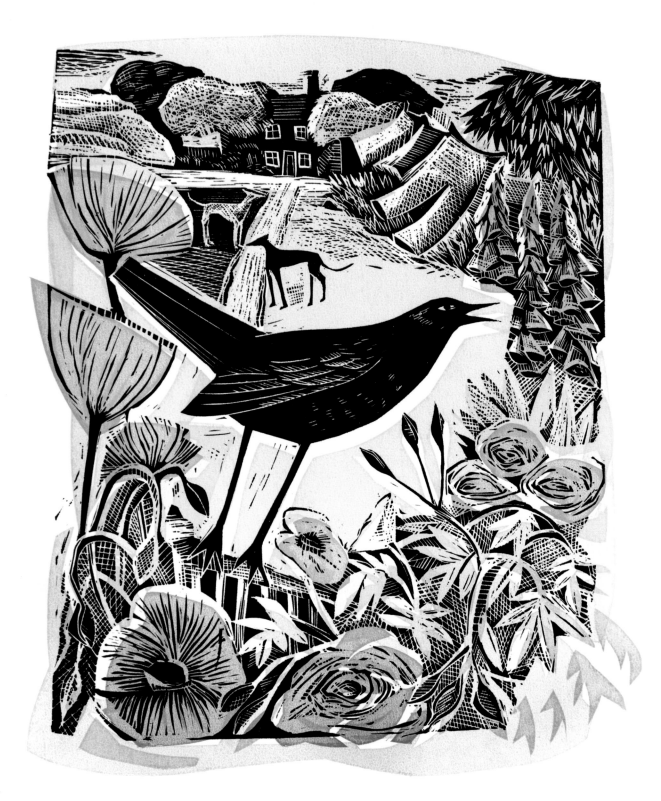

August

21 Monday

22 Tuesday

23 Wednesday

◐ 24 Thursday

25 Friday

26 Saturday

27 Sunday

August/September

28 Monday

Summer Bank Holiday (UK except Scot)

29 Tuesday

30 Wednesday

Raksha Bandhan

31 Thursday ○

1 Friday

2 Saturday

3 Sunday

Father's Day (AU, NZ)

Heading Home
© Angela Harding 2022

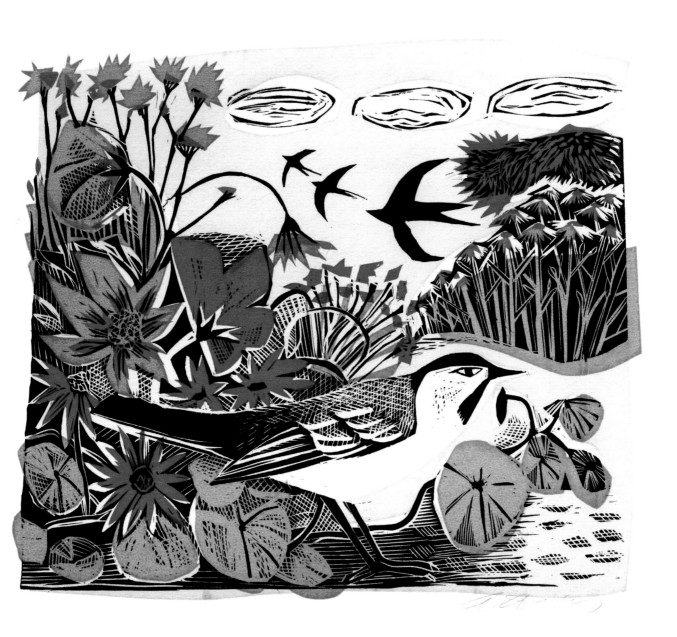

September

4 Monday

5 Tuesday

6 Wednesday ◑

Krishna Janmashtami

7 Thursday

8 Friday

9 Saturday

10 Sunday

Grandparents Day (USA, Canada)

September

11 Monday

12 Tuesday

13 Wednesday

14 Thursday

15 Friday

16 Saturday

Jewish New Year (Rosh Hashanah) begins

17 Sunday

Jewish New Year (Rosh Hashanah) ends

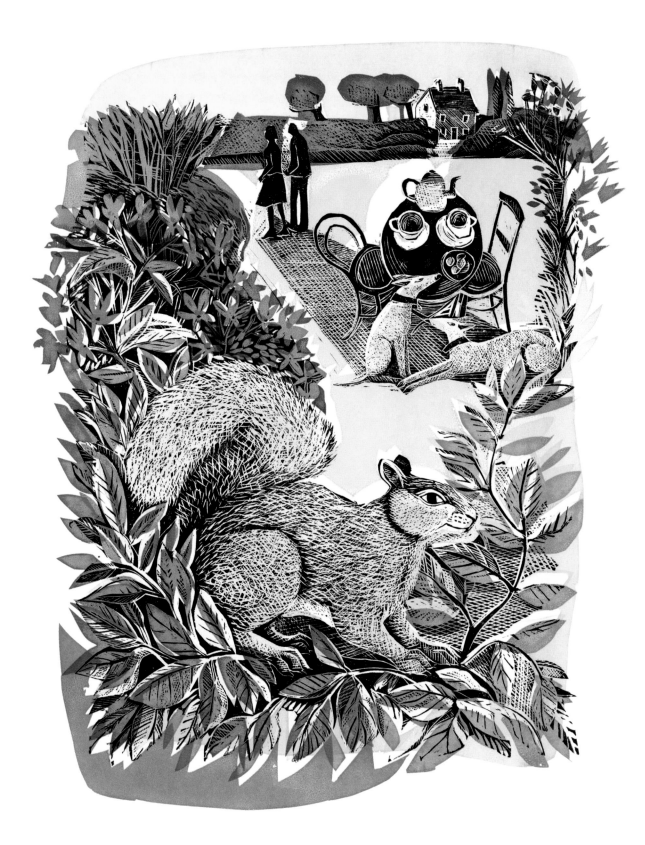

September

18 Monday

Ganesh Chaturthi
Respect for the Aged Day (Japan)

19 Tuesday

20 Wednesday

21 Thursday

International Day of Peace

22 Friday

23 Saturday

Autumn Equinox

24 Sunday

Heritage Day (SA)

Visitors for Tea
© Angela Harding 2022

September/October

25 Monday

Heritage Day (SA) (observed)
Day of Atonement (Yom Kippur)

26 Tuesday

27 Wednesday

Birthday of the Islamic Prophet Muhammad

28 Thursday

29 Friday ○

Pitr-paksha begins

30 Saturday

First Day of Sukkot (Feast of Tabernacles)

1 Sunday

Highland Deer
© Angela Harding 2022

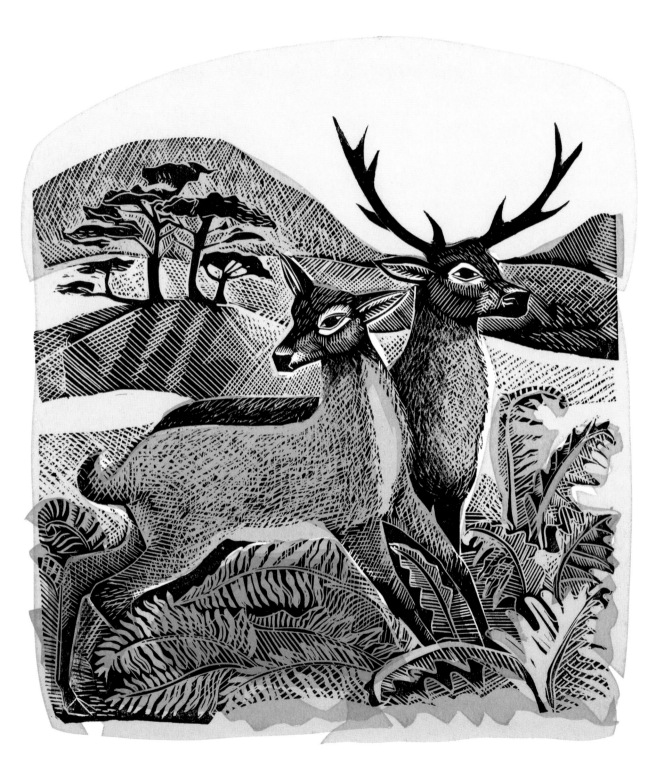

October

2 Monday

3 Tuesday

4 Wednesday

5 Thursday

6 Friday ◑

Last Day of Sukkot (Feast of Tabernacles)

7 Saturday

Shemini Atzeret

8 Sunday

Simchat Torah

October

9 Monday

Sports Day (Japan)
Thanksgiving Day (Canada)
Indigenous Peoples' Day, Columbus Day (USA)

10 Tuesday

11 Wednesday

12 Thursday

13 Friday

14 Saturday

Pitr-paksha ends

15 Sunday

Sharad Navaratri begins

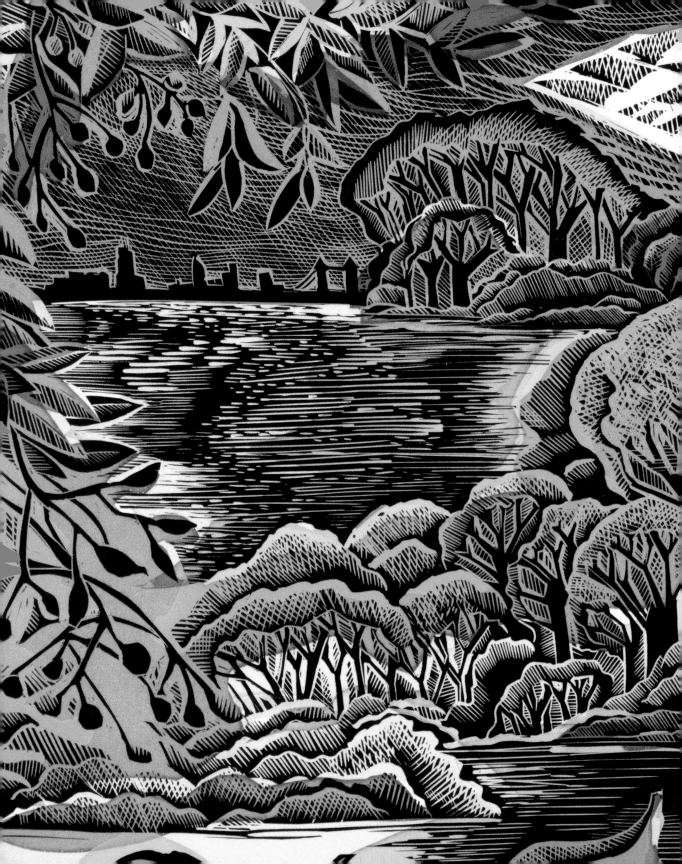

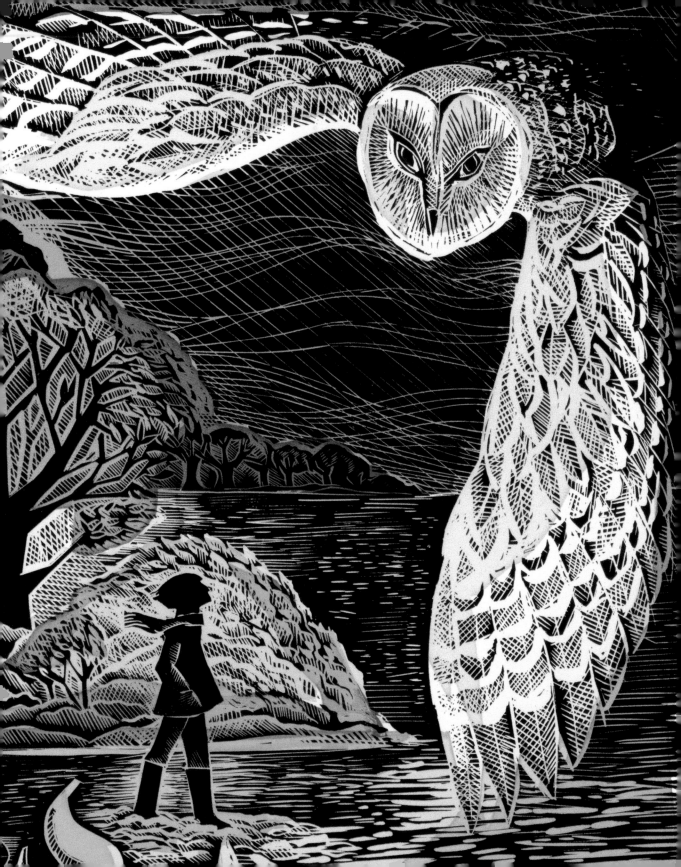

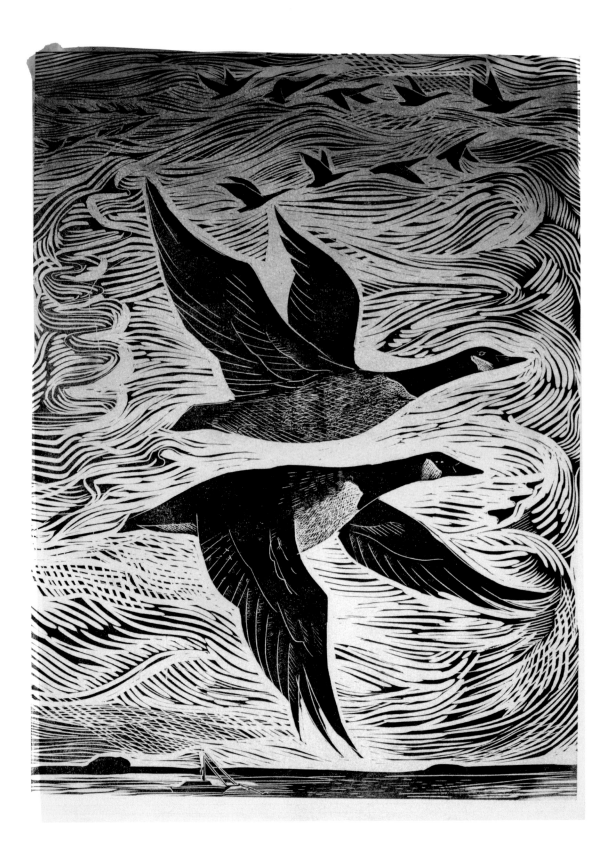

October

16 Monday

17 Tuesday

18 Wednesday

19 Thursday

20 Friday

21 Saturday

22 Sunday

October

23 Monday

<div align="right">Labour Day (NZ)</div>

24 Tuesday

<div align="right">Dussehra</div>
<div align="right">Sharad Navaratri ends</div>

25 Wednesday

26 Thursday

27 Friday

28 Saturday ○

29 Sunday

<div align="right">British Summer Time ends</div>

October/November

30 Monday

October Bank Holiday (Éire)

31 Tuesday

Halloween

1 Wednesday

All Saints' Day

2 Thursday

3 Friday

Culture Day (Japan)

4 Saturday

5 Sunday

November

6 Monday

7 Tuesday

8 Wednesday

9 Thursday

10 Friday

Veterans Day (USA) (observed)

11 Saturday

Remembrance Day
(Armistice Day)
Veterans Day (USA)

12 Sunday

Diwali
Bandi Chhor Divas
Remembrance Sunday

Redshank and Oyster Catcher
© Angela Harding 2022

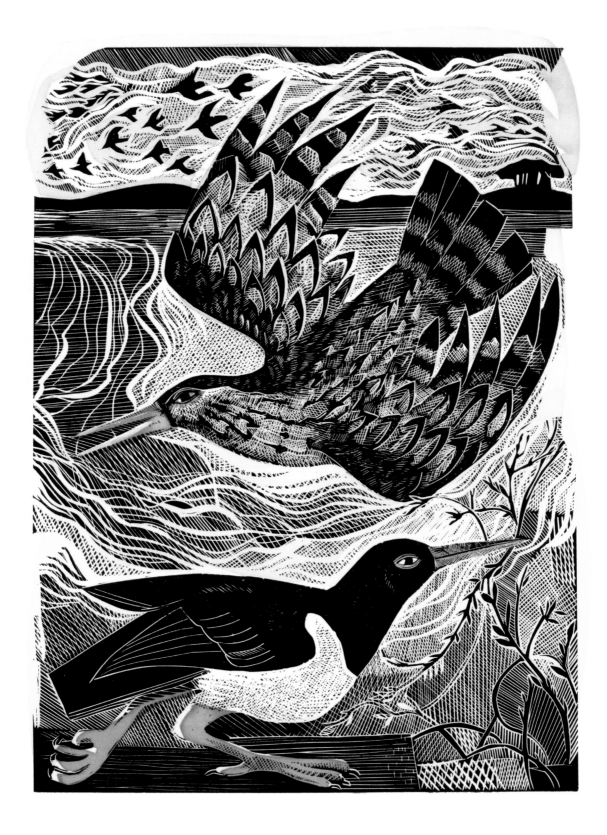

November

13 Monday ●

14 Tuesday

15 Wednesday

16 Thursday

17 Friday

18 Saturday

19 Sunday

November

20 Monday

21 Tuesday

22 Wednesday

23 Thursday

Thanksgiving Day (USA)
Labour Thanksgiving Day (Japan)

24 Friday

Martyrdom of Guru Tegh Bahadur

25 Saturday

26 Sunday

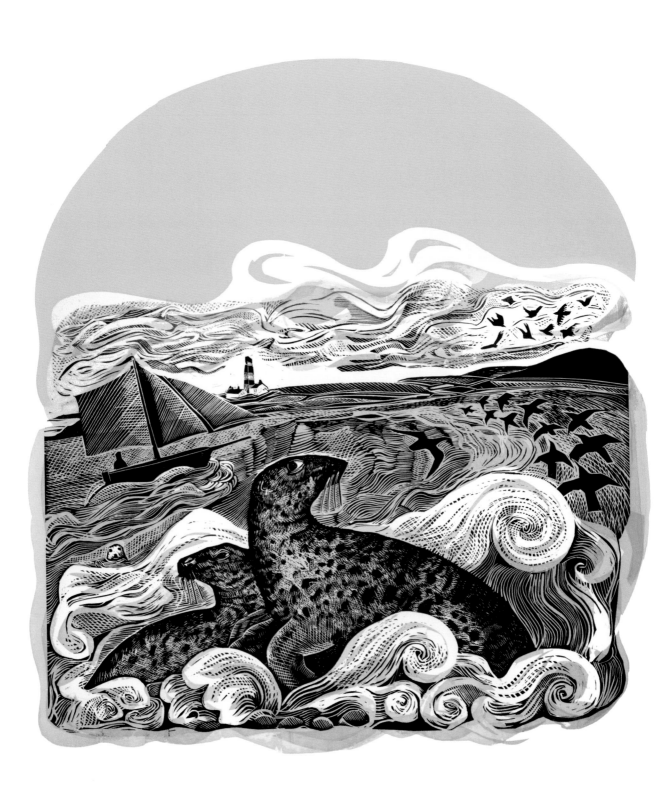

November/December

○ 27 Monday

Birthday of Guru Nanak

28 Tuesday

29 Wednesday

30 Thursday

St Andrew's Day (Scot)

1 Friday

2 Saturday

3 Sunday

Advent Sunday

Seal Song
© Angela Harding 2022

December

4 Monday

5 Tuesday ◑

6 Wednesday

7 Thursday

8 Friday

Bodhi Day
Hanukkah begins

9 Saturday

10 Sunday

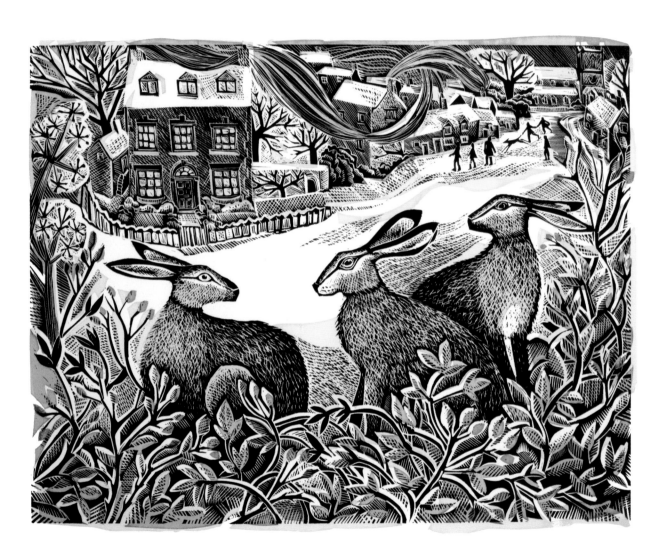

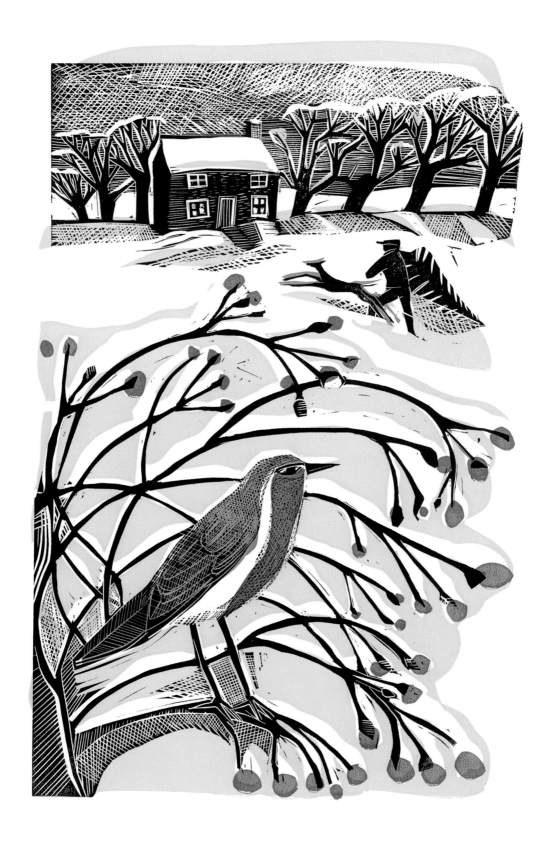

December

11 Monday

12 Tuesday

13 Wednesday

14 Thursday

15 Friday

Hanukkah ends

16 Saturday

Day of Reconciliation (SA)

17 Sunday

Bringing Back the Tree
© Angela Harding 2022

December

18 Monday

19 Tuesday

20 Wednesday

21 Thursday

22 Friday

Winter Solstice

23 Saturday

24 Sunday

Christmas Eve

Winter Wonderland
© Angela Harding 2022

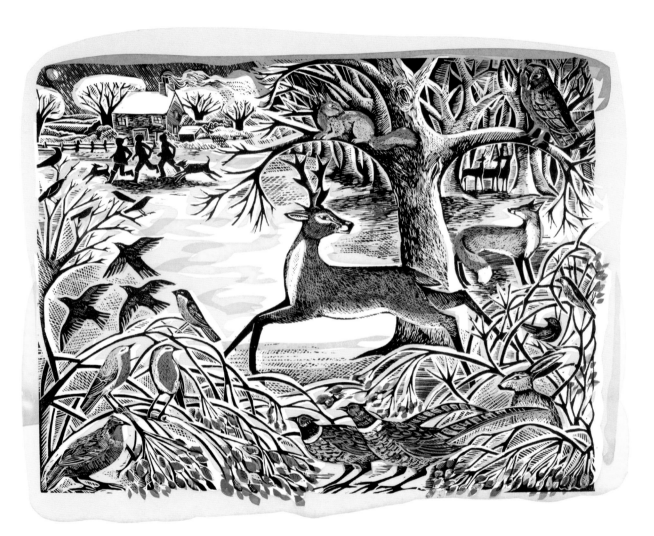

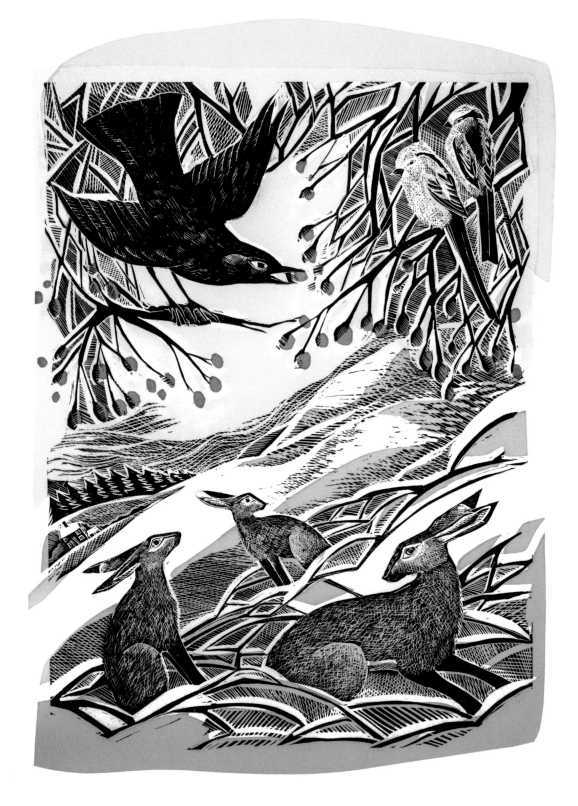

December

25 Monday

Christmas Day

26 Tuesday

Boxing Day
Day of Goodwill (SA)
St Stephen's Day (Éire)

○

27 Wednesday

28 Thursday

29 Friday

30 Saturday

31 Sunday

New Year's Eve

Hares in Conversation
© Angela Harding 2022

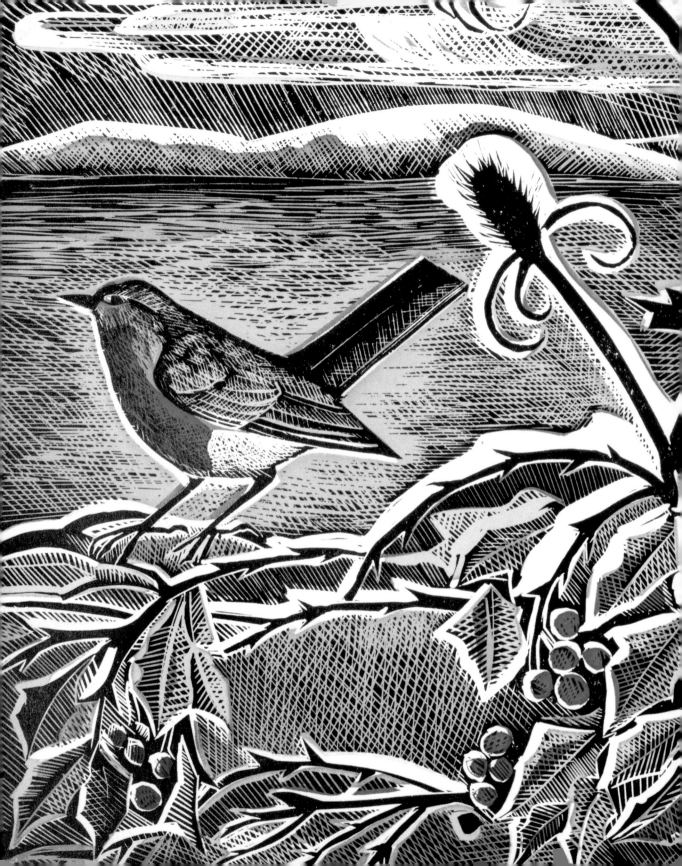

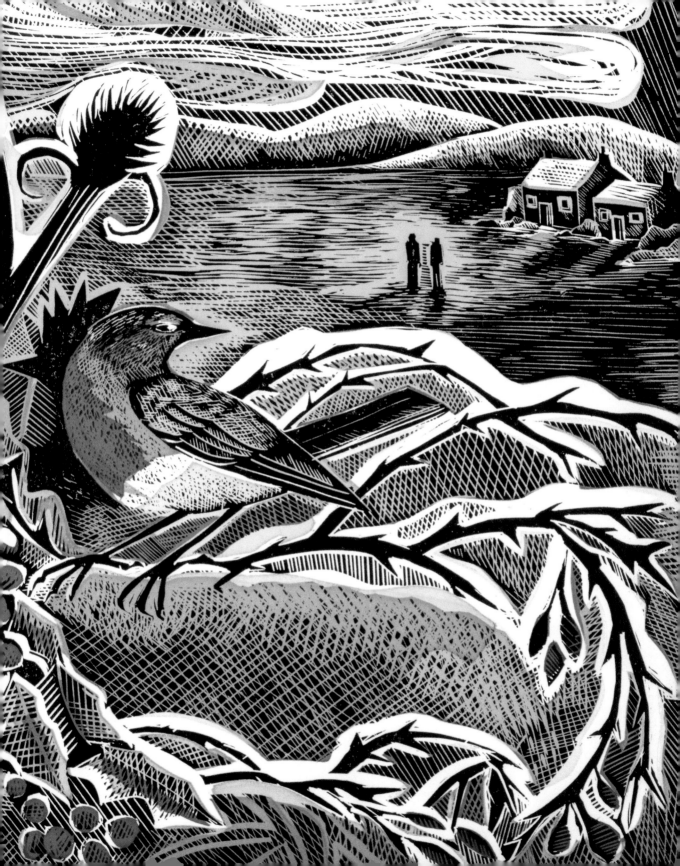

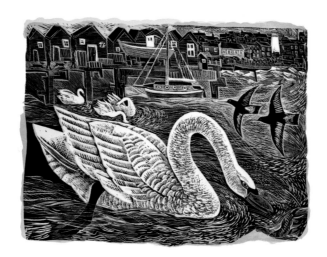

Southwold Swan
© Angela Harding 2022